FELIXSTOWE
HISTORY TOUR

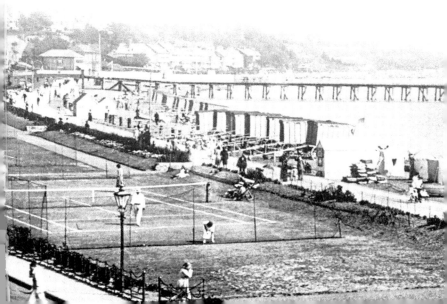

ACKNOWLEDGEMENTS

In 2012 I wrote *Felixstowe Through Time* and much of the information here comes from that and from a further very enjoyable visit this year. For that book I referred to the research I had done for *Coastal Resorts of East Anglia* (1982). I consulted the Ward Lock guides and town guides for 1936, 1947, 1950, 1965, 1974 and 1980; Robert Malster's *Felixstowe, A Pictorial History* (Phillimore, 1992); *Felixstowe at Leisure* by Phil Hadwen, John Smith, Ray Twidale, Peter White and Neil Wylie (1996); *Felixstowe – Then and Now* by Mike Durrant (imaginaire, 2010); and various websites.

My special thanks to Clare Baker of Felixstowe Forward, and, as usual, to all at Amberley.

To those who love the history of the seaside and
have confidence in its future.

First published 2018

Amberley Publishing
The Hill, Stroud,
Gloucestershire, GL5 4EP
www.amberley-books.com

Copyright © Michael Rouse, 2018
Map contains Ordnance Survey data
© Crown copyright and database right
[2018]

The right of Michael Rouse to be
identified as the Author of this work has
been asserted in accordance with the
Copyrights, Designs and Patents Act 1988.

ISBN 978 1 4456 7891 7 (print)
ISBN 978 1 4456 7892 4 (ebook)

British Library Cataloguing in
Publication Data.
A catalogue record for this book is
available from the British Library.

Origination by Amberley Publishing.
Printed in Great Britain.

INTRODUCTION

Felixstowe promotes itself as an Edwardian resort as this was when the town really burst into life as a fashionable seaside destination with a pier, some magnificent hotels and its wonderful landscaped gardens down the cliffs.

Travel writers and guide compilers give a broad timeline for Felixstowe's development in the nineteenth century. William White's Directory of 1844 describes 'a delightfully situated bathing place on the sea coast ... its parish has 552 souls, and about 1170 acres of land, forming a narrow tract, terminating in bold cliffs on the sea shore'. He mentions that C. Meadows of Ipswich and other speculators had built houses and cottages to let to visitors, and that J. C. Cobbold, who occupied a local mansion, had built a hotel there in 1839.

C. S. Ward is hardly optimistic in his 'Thorough Guide' from the 1880s:

> This place consists of a row of shops, &c., facing the beach and some good villas, the Bath Hotel, and the Church on the cliff, and that is about all. It is bright enough on a bright summer's day, and as the spot chosen for the Suffolk Convalescent Home may be assumed to be healthy, but the marshes on two sides of the town suggest ague in winter. The bathing and sands are excellent, and the cliff of Red Crag ending in Felixstowe Point, with villas and trees above, is picturesque.

The visit from the Empress of Germany, her children and servants in 1891 greatly boosted the town's fortunes, and it was described as fashionable just seven years later in 1898 by West Carnie in his book *In Quaint East Anglia*. 'It is not at all like any other watering place,' he wrote, 'the houses all suggest prosperous residential owners rather than the usual seaside landlady, and I fancy the ordinary lodgings must be at a premium in Felixstowe during the summer months ... the houses are scattered about here, there and everywhere, over a huge area. The consequence is that there are three stations for a town of barely three thousand inhabitants.'

While Colonel George Tomline (1813–89) – whose company founded the Port of Felixstowe and brought the railway to the town – had ambitious

plans for development, it was the MP John Chevallier Cobbold (1797–1882) – brewer, railway pioneer, and MP for Ipswich from 1847 to 1868 – after whom Cobbold's Point is named, who was as much as anyone responsible for the development of Felixstowe as a select seaside resort.

In 1905 the Coast Development Corporation built the pier with an electric tramway to connect with the Belle Steamers. At half a mile long, it was the third longest in the country. Felixstowe was heavily fortified during the war – just as it had been during the Napoleonic Wars – as the row of Martello towers bear witness. There were tank traps and barbed wire all along the seafront, and the pier – like others along the east coast – was blown in two in 1940 by Royal Engineers. The pier has been owned by the Threadwell family since 1966. It underwent a major renovation in 2017 and now has a spectacular new boardwalk.

Just after the Second World War, the 1947 town guide said:

> Many things have altered, and more will alter no doubt as time goes on, but one thing which has not changed is the situation of Felixstowe, perched on its cliff and overlooking the broad sweep of its beautiful Bay, with the Spa gardens and their riot of colour and flowers reaching down to the edge of the sea.

In 2015 the wonderful series of eight Grade II-listed gardens from the Town Hall running down to Cliff House's garden were restored with money from the Heritage Lottery Fund to something like their former glory, recreating a priceless feature for walking, sitting, and relaxing – hopefully in the sun, but certainly with great sea views.

KEY

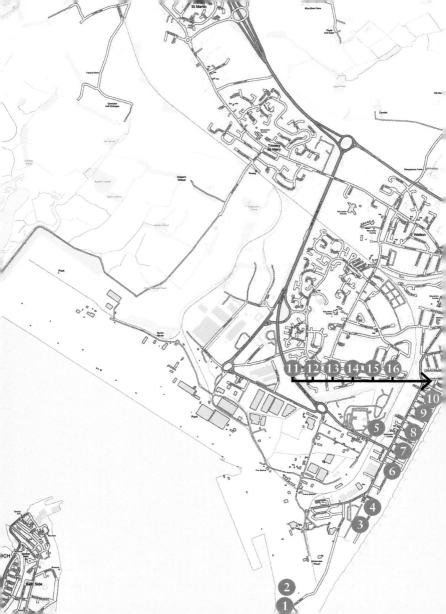

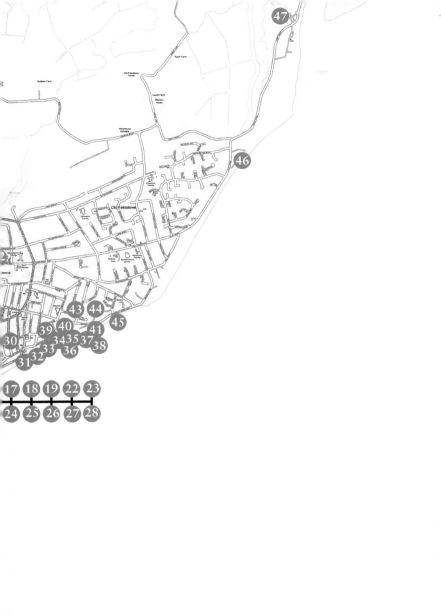

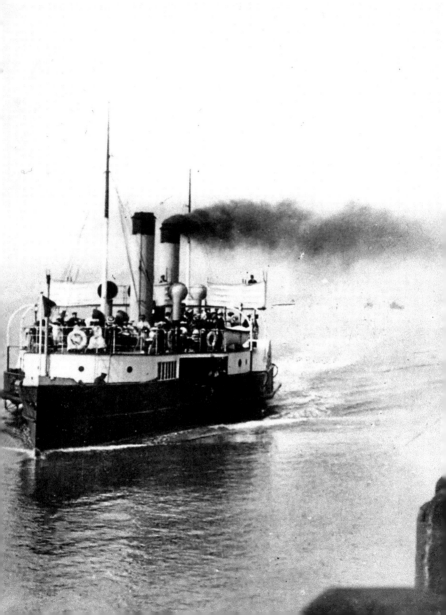

1. FELIXSTOWE OLD PIER, C. 1910

In the 1870s Colonel George Tomline began to develop the new Port of Felixstowe to rival Harwich, planning a new rail link from Ipswich and a pier for the steamers to land. The Felixstowe Railway & Pier Co. took the railway line along the pier at the port. Work began on the dock in 1881 and it was opened in 1884.

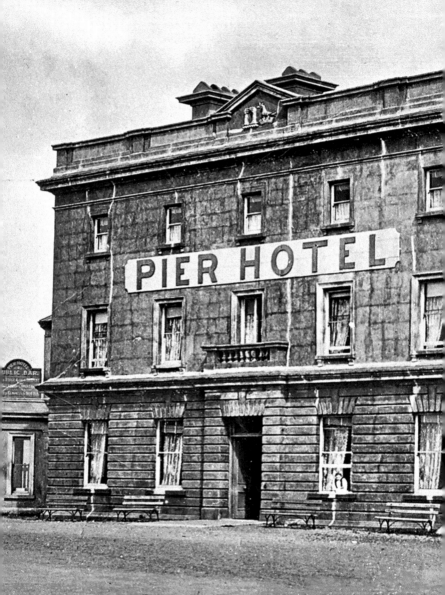

2. THE PIER HOTEL

The Pier Hotel was opened in 1877 as part of Tomline's ambitious plans, and was intended primarily for passengers using the steamers that he hoped would operate to northern Germany. During the First World War the hotel served as a hospital and during the Second World War it was the headquarters for HMS Beehive, a royal naval base for motor torpedo boats, motor gun boats and motor launches. Known in later years as the Little Ships Hotel, it was swallowed up in the development of the port, closing in 1990 and lost in a fire soon after.

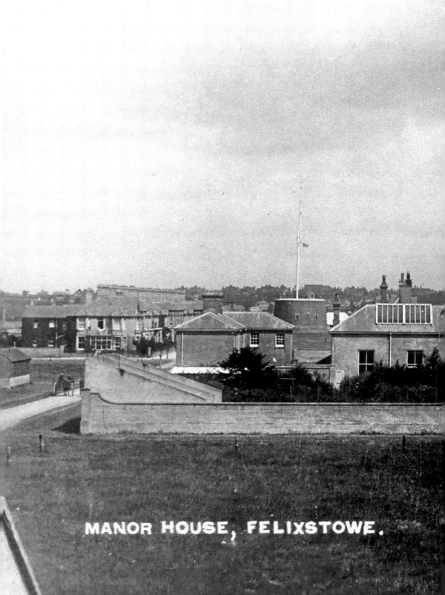

MANOR HOUSE, FELIXSTOWE.

3. MANOR HOUSE, C. 1910

Tomline's vision was to create a new resort along the southern seafront, and in 1877 he built the Manor House Hotel and Manor Terrace, which can be seen in the background. The hotel, however, was unsuccessful because Felixstowe was developing more along the cliffs around the Bath Hotel. In 1888 the Manor became Tomline's Felixstowe home. After his death in 1889 it became a golf club, then a preparatory school in 1900. During the First World War it was requisitioned as a naval officers' billet. Now much reduced in height, it is part of the Suffolk Sands caravan park.

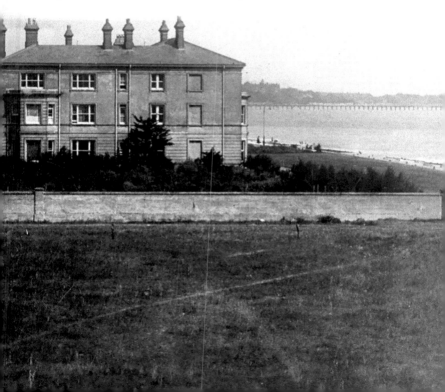

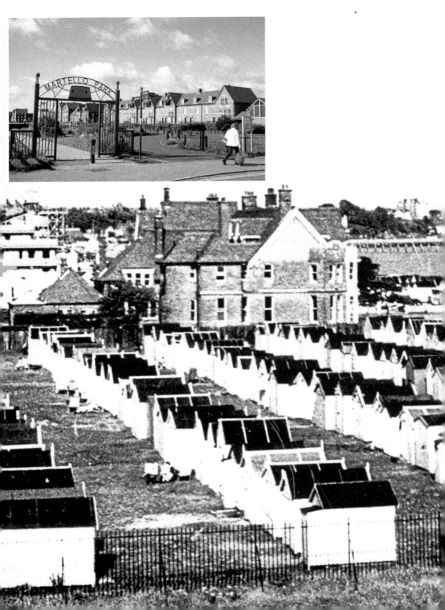

4. BEACH HUTS, WIRELESS GREEN, C. 1950

Between the Manor House and the Herman de Stern Convalescent Home were these extraordinary rows of beach huts. The Victorian Manor Terrace lies behind this site and seems to have been as far as Tomline's new resort reached. The 'Wireless Green' reference on the postcard is to the naval radio station that used to be at Martello Tower P. This is now Martello Park housing development, which has a fine children's play area.

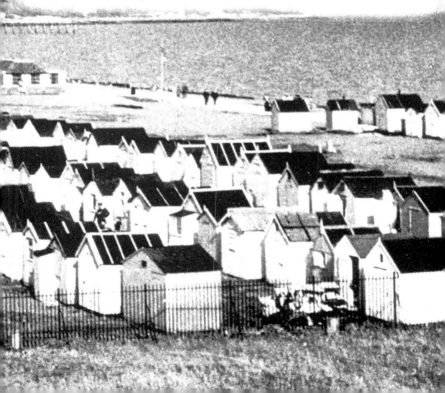

5. BEACH STATION

This station was opened in 1877 when Tomline's railway line from Ipswich reached the port. In 1887 the line was bought by the Great Eastern Railway. At first it was called Felixstowe Town station, but when a new station was opened on Hamilton Road in 1898 it became known as Felixstowe Beach station. The Felixstowe Old Pier station closed in 1951, while this one remained open until 1967. Despite considerable local protests, the building was eventually demolished in 2004.

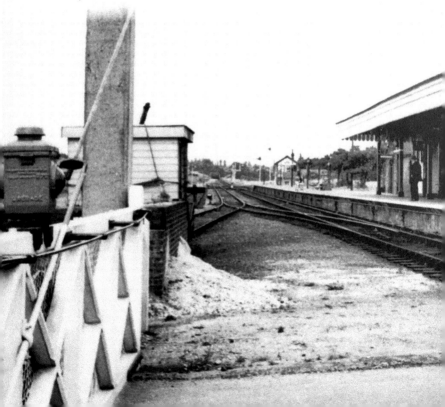

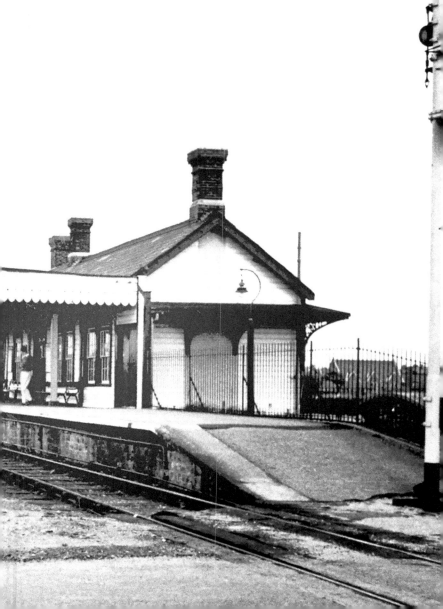

6. HERMAN DE STERN CONVALESCENT HOME, C. 1910

Baron de Stern (1815–87) was a banker and one of the wealthiest men in Britain. This home for male patients of the London Hospital was built and endowed by his widow in his memory and opened in 1902. It became a military hospital during the Second World War, and the building was eventually sold by the NHS around 1980. It was destroyed by fire in 2005.

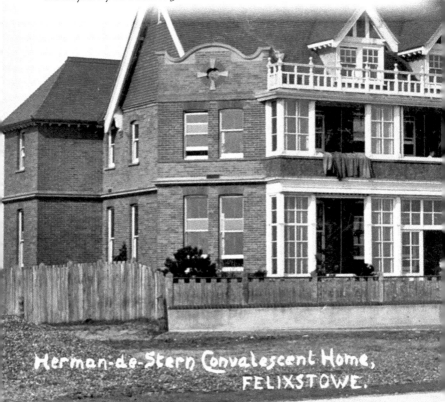

Herman-de-Stern Convalescent Home, FELIXSTOWE.

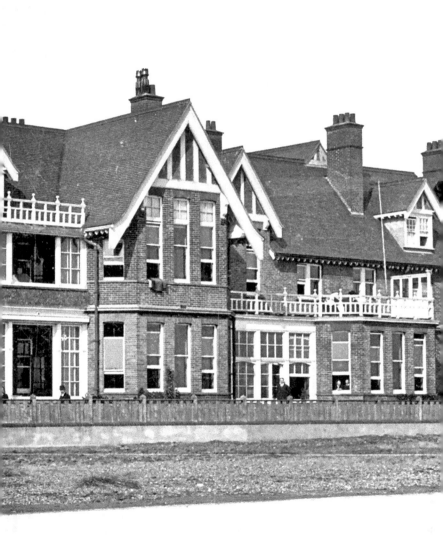

7. CAVENDISH HOTEL, C. 1938

The splendid Cavendish on Sea Road opened in 1937. In its heyday in the 1950s, it boasted 'Excellent cuisine, produce from own farm, ample garage accommodation, central heating and hot and cold water in all bedrooms.' In 1953 east coast floods hit Felixstowe; thirty-nine people died and hundreds were made homeless, and the Cavendish opened as a rescue centre for two weeks. A popular music centre for young people in the 1970s, it was demolished in 1988 and the site is now used as a Sunday market.

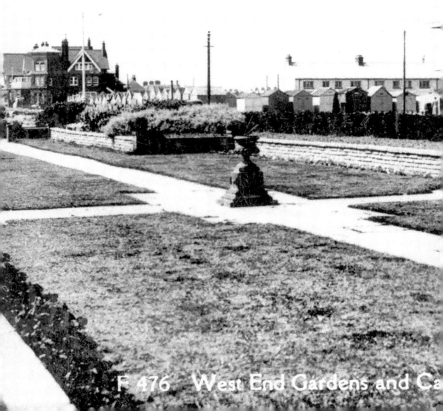

F 476 West End Gardens and Ca

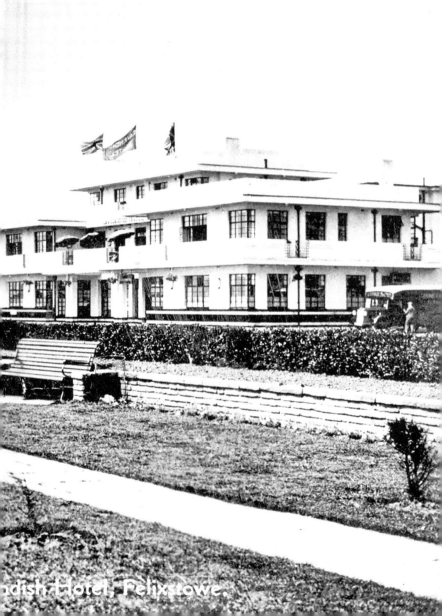

ndish Hotel, Felixstowe.

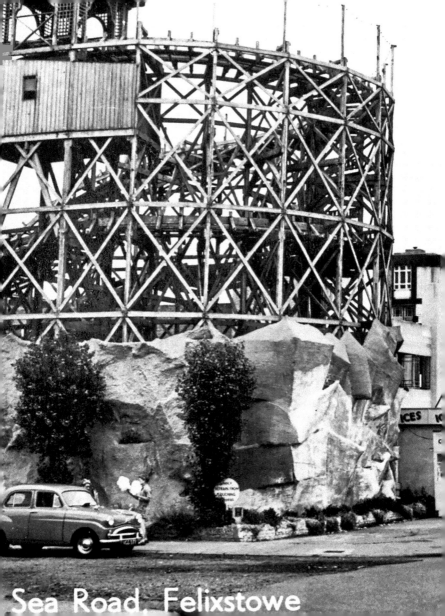

Sea Road, Felixstowe

8. SEA ROAD, C. 1955

Billy Butlin opened the amusement park here in 1932. A feature of the park was the wooden rollercoaster, which was eventually demolished in 1976. Manning's have run the park since the end of the Second World War and have owned it since 1995. In the 1947 guide, Butlin's Amusement Park claimed the 'longest snack bar in East Anglia'. There were dodgems, Big Eli wheel, Galloping Horses, Loop o'Planes, a ghost train and the Caves of Love, while today there are the waltzers, children's rides, indoor crazy golf, markets, events, indoor amusements and food outlets.

9. PUBLIC TENNIS COURTS, C. 1920

The promenade was constructed between 1903 and 1904, and the gardens along Sea Road were laid out before the First World War. Tennis was a popular holiday sport, with many hotels having their own courts. The Felixstowe Lawn Tennis Club, founded in 1884 on Bath Road, is still very active, hosting the East of England Tennis Championships. By the mid-1930s this area was a putting green.

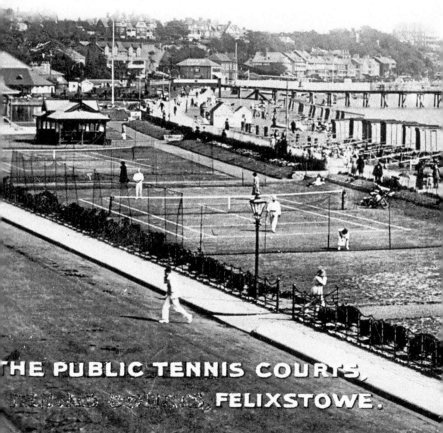

THE PUBLIC TENNIS COURTS FELIXSTOWE.

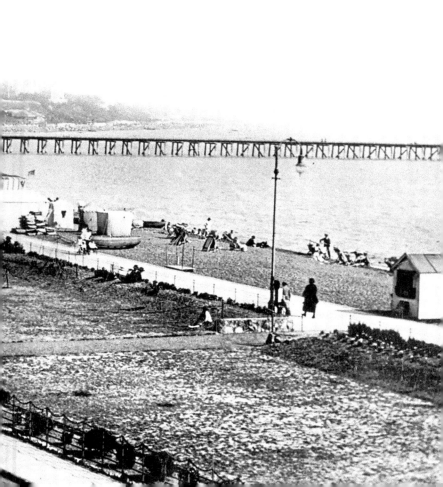

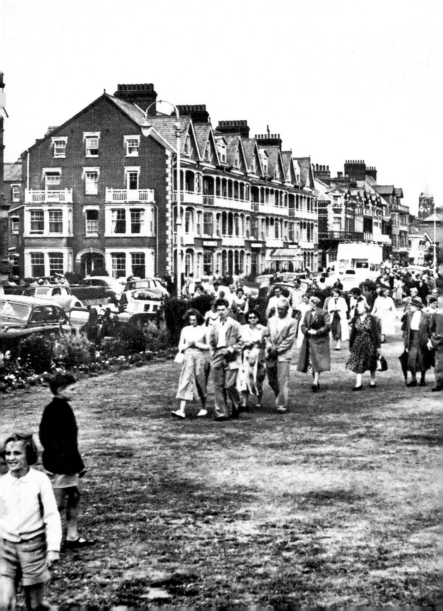

10. WEST END LAWNS, C. 1953

The image here was possibly taken on a bank holiday, when day trippers flocked to the seaside.

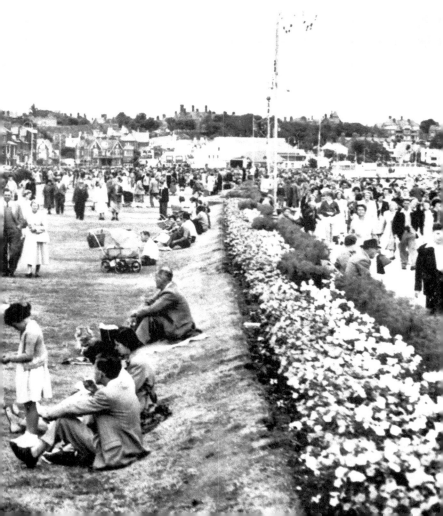

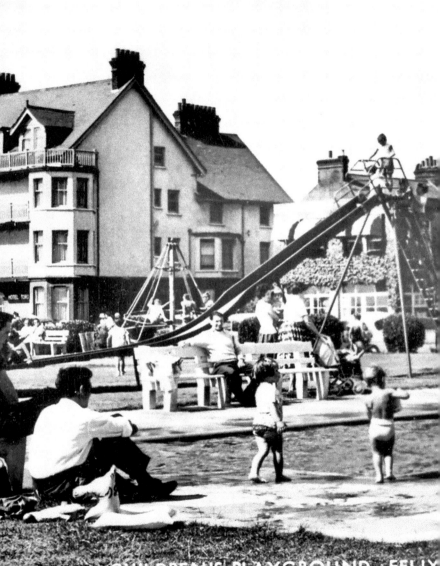

CHILDREN'S PLAYGROUND, FELIX

11. CHILDREN'S PLAYGROUND, C. 1955

A small children's play area and paddling pool was situated in the gardens opposite the Felix Court Hotel. The hotel closed in 1972 and part of it is now the Felsto Arms.

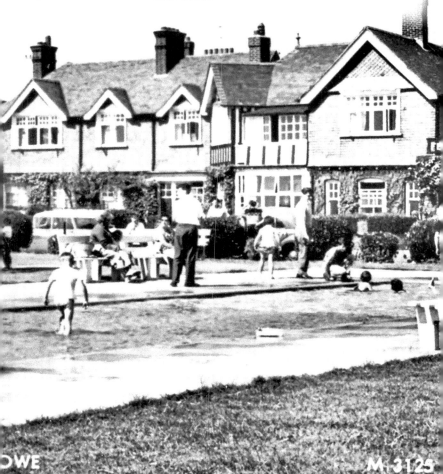

OWE

M 3125

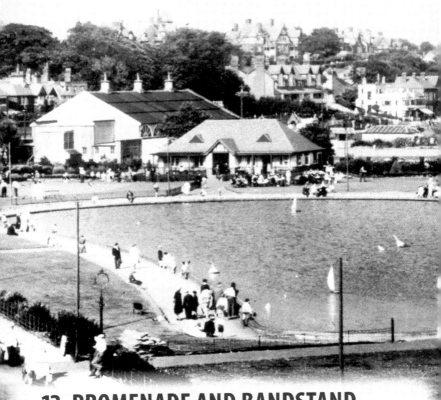

12. PROMENADE AND BANDSTAND, C. 1933

The model yacht pond was opened in July 1910 and the bandstand was added around 1912. In the background is the first Pavilion, which was built in 1910 by Will C. Pepper. The Pier Pavilion was a popular concert hall and dance hall. The pavilion was extended in 1938 and the bandstand was removed at the same time.

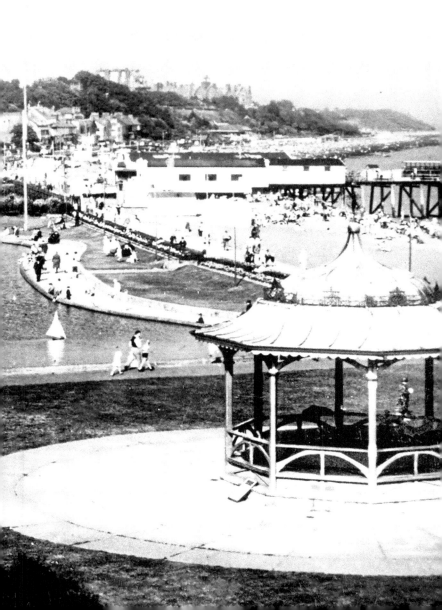

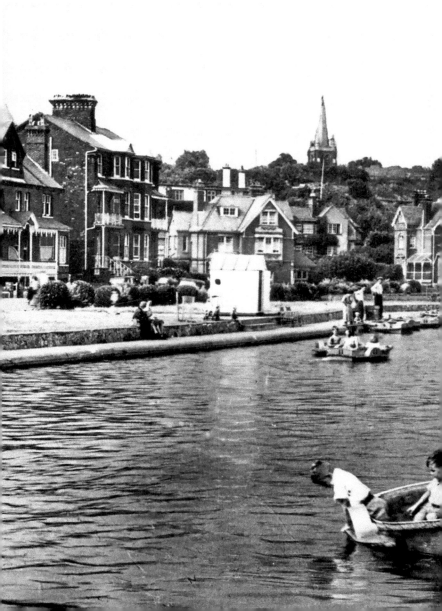

13. BOATING POND AND PIER PAVILION, C. 1955

When the popularity of model boats faded, paddle boats were introduced. No life jackets were needed, though, as the water was only around 2 feet 6 inches deep. The lake was later reduced in size, and then closed completely in 2010.

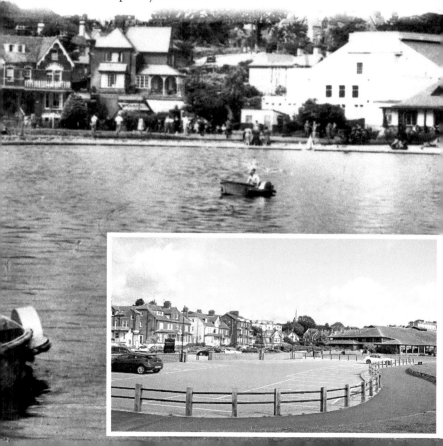

14. THE BOWLING GREEN AND PIER PAVILION, C. 1948

Felixstowe, which became a 'front line' town during the war, was soon back in the holiday business. The Pier Pavilion was at the heart of its attraction. In 1947 it was advertised as 'The West End of the East Coast'. During July, August and September there were afternoon and Sunday orchestral concerts, and every evening except Saturdays John Barryman and Adele Wessely presented their super concert party: 'Evening Stars – The Show of Shows'. With two bands playing, Saturday evenings were for dancing. The old bowling green now provides car parking for the leisure centre.

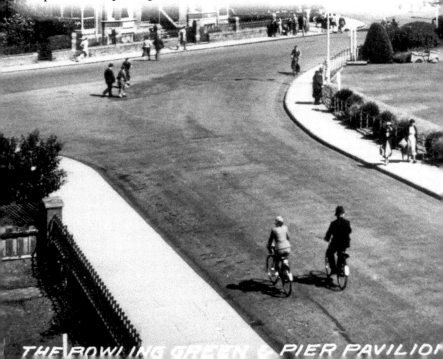

THE BOWLING GREEN & PIER PAVILION

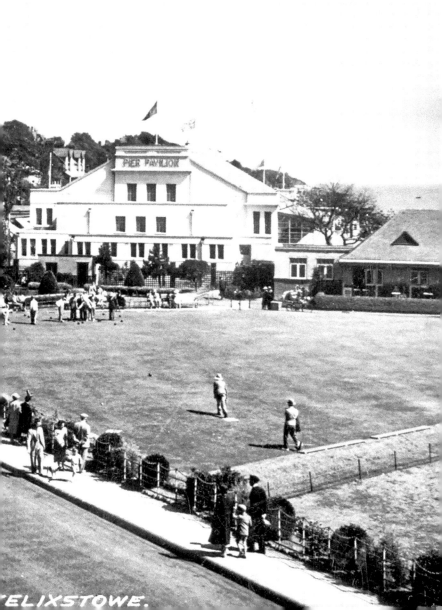

PIER PAVILION

FELIXSTOWE.

15. SEA ROAD AND SOUTH HILL, C. 1920

The view from South Hill once took in the hotels along Sea Road, the boating lake and the sweep of the gardens. Here, the Melrose Hotel can be seen on Sea Road and beyond that is The Chatsworth. The bowling green is being mown by hand, a horse-drawn carriage passes by, and a delivery boy with his basket heads down the slope towards Sea Road.

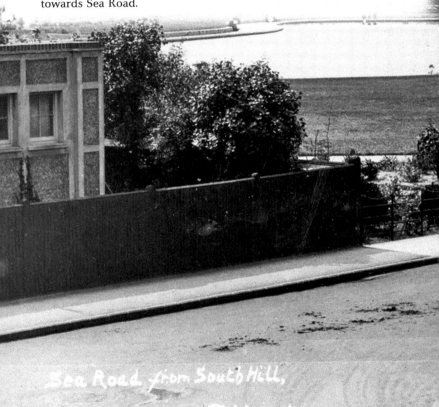

Sea Road from South Hill, Felixstowe.

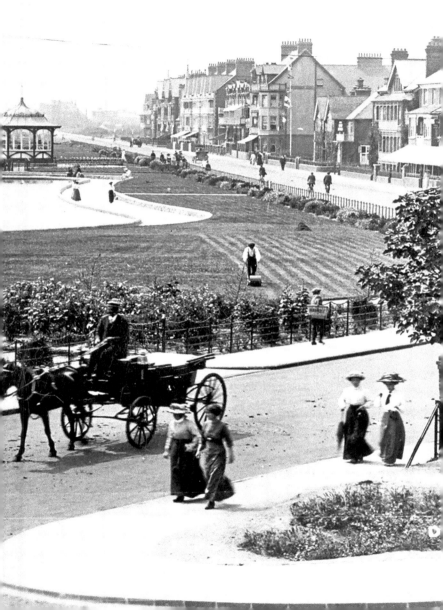

16. THE PIER PAVILION, C. 1948

Season after season in the 1960s and 1970s, the 'Fabulous Fingers of Handel' at the £2,000 Hammond Organ was a much-loved regular at the Pier Pavilion. Mornings and afternoons there were concerts and 'entertainment for the whole family', and there was always a resident orchestra. In 1983 the Pier Pavilion was demolished and the following year the new leisure centre was built on the site with its indoor swimming pool, fitness suites and enormous dark roof.

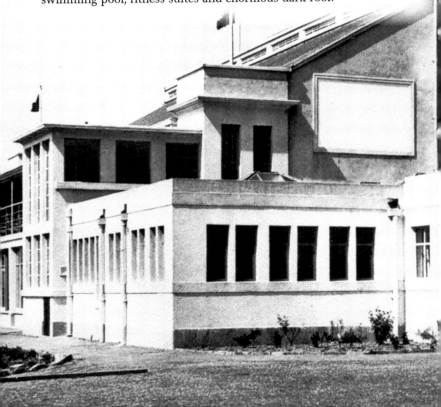

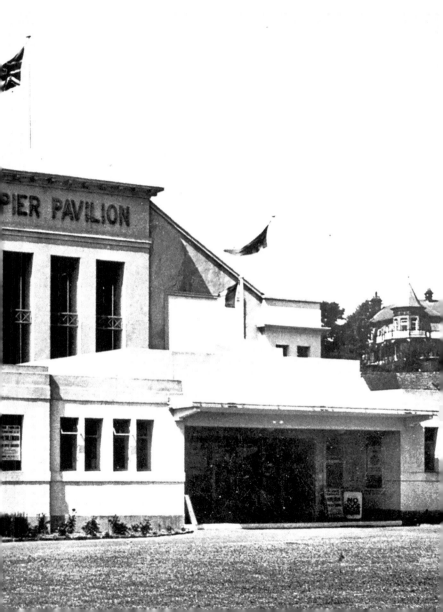

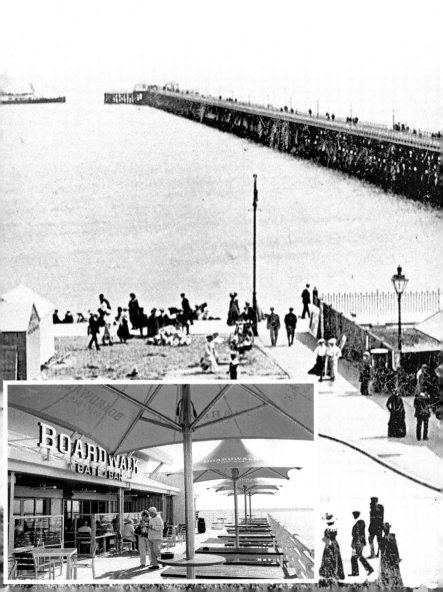

17. THE PIER, C. 1915

The pier was very much a practical structure, and had a tramway connecting with the Belle Steamers. There was a bridge over the pier gardens known as The Pullover, which went in the mid-1920s as the shore end was developed as an entertainment centre.

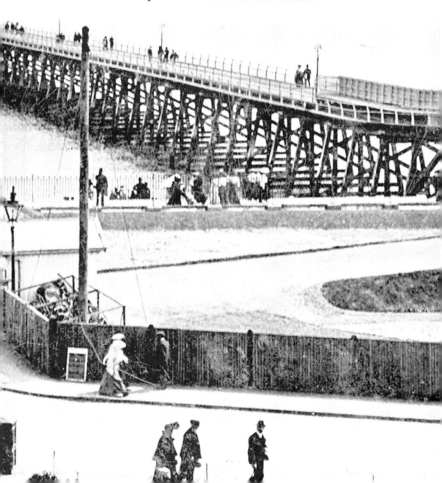

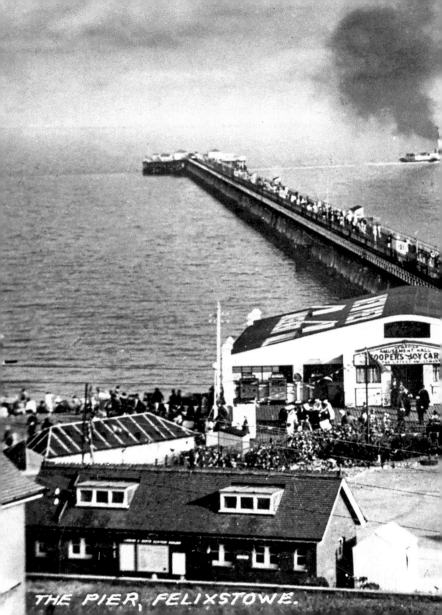

THE PIER, FELIXSTOWE.

18. THE TOWN PIER, C. 1936

The Belle Steamers ended their service after the First World War, although the *Queen of Southend* ran a regular service to London until 1939. The Second World War ended the tramway, and, like many other piers, this one was partially destroyed in case of invasion. It was never fully rebuilt and when reopened was 450 feet in length, with much of it condemned as unsafe in the early 2000s.

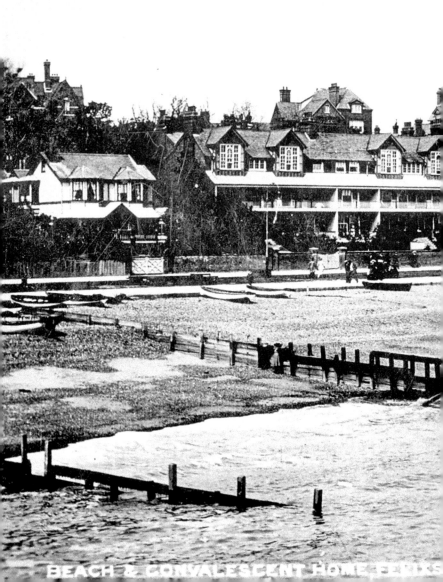

BEACH & CONVALESCENT HOME FELIX

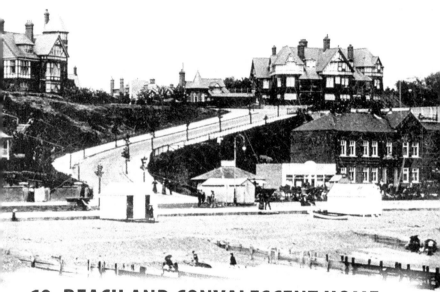

19. BEACH AND CONVALESCENT HOME, C. 1908

The much-publicised benefits of sea air and being dipped in seawater led to many convalescent homes being built at coastal resorts. The Suffolk Convalescent Home opened in around 1864, and by the early years of the twentieth century had been almost entirely rebuilt. The Ward Lock Guide for 1921 described it as a 'well-managed institution for the sick poor among the artisan classes and is liberally supported locally'. The home and villa next door were demolished in 1967 and the site is now a car park.

Felixstowe from the Shelter

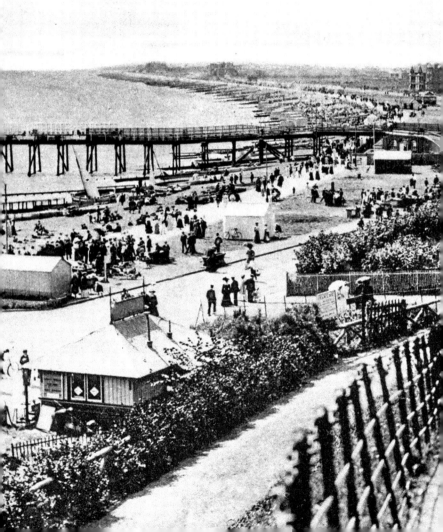

20. FELIXSTOWE FROM THE SHELTER, C. 1909

A classic view of the resort from Convalescent Hill looking across the new pier and the gardens towards Sea Road. Felixstowe is developing rapidly and the large hotels are beginning to fill the horizon. The side of the Suffolk Convalescent Home is prominent.

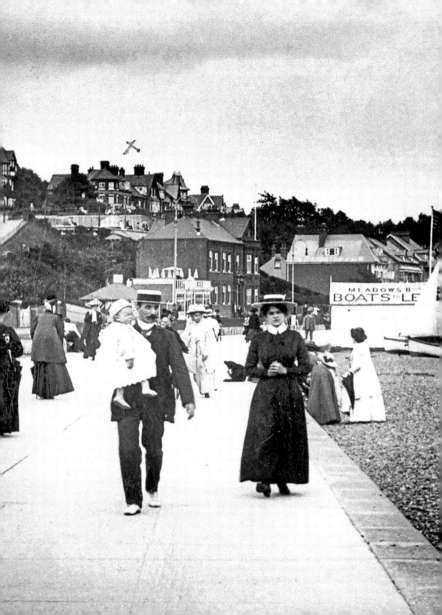

21. PROMENADE AND BEACH, C. 1912

A view of people on the beach and walking along the promenade around 1912.

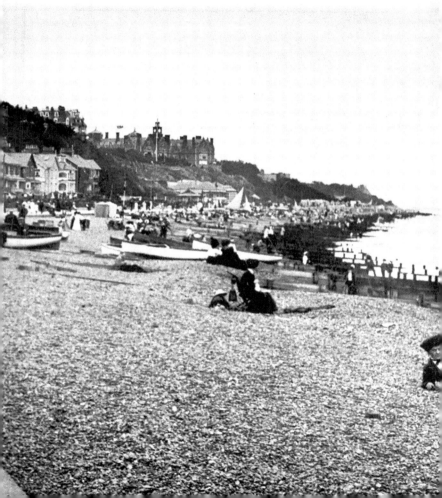

22. GOAT CARTS, C. 1908

The official Felixstowe and Walton Urban District Council stand for goat carts was at the foot of Convalescent Hill. Holidaymakers could also enjoy donkey rides, as the Empress of Germany's children had done in 1891.

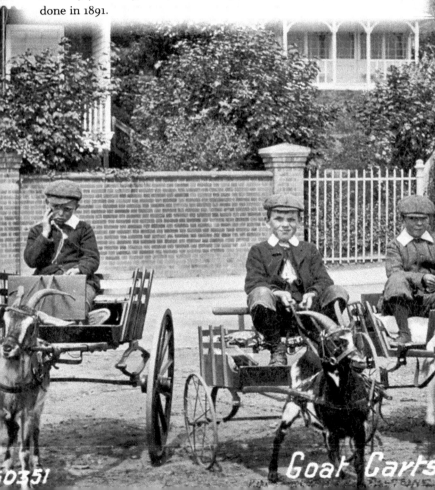

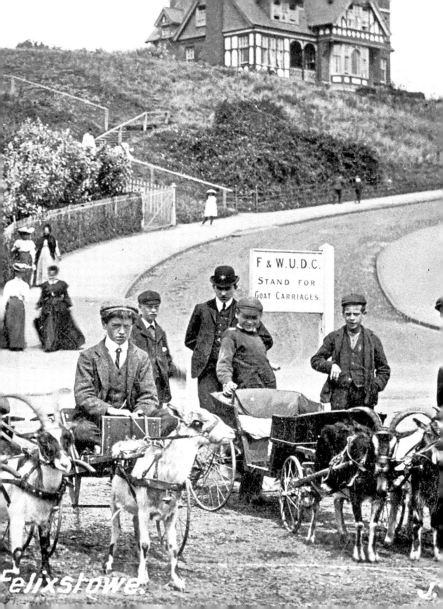

F & W.U.D.C.
STAND FOR
GOAT CARRIAGES

Felixstowe.

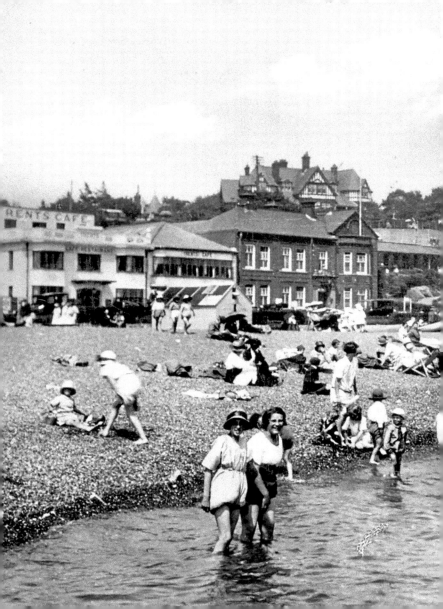

23. SOUTH BEACH, C. 1933

Trent's Café can be clearly seen on the left, having been recently rebuilt and enlarged. By the 1950s Trent's Café boasted '200 feet of Windows overlooking the sea ... the largest café-restaurant in Felixstowe seating 500'. It was competing with Millars, Cordy's Regal Café Restaurant (also with seating for 500), the Empire Café (which also catered for parties), and Cordy's Alexandra Café. By the mid-1960s this fine art deco building had become the town council's information bureau, but it became a restaurant again in 2017.

24. THE BEACH, C. 1910

Although Colonel Tomline's vision of the new resort at the Landguard end had faltered, Felixstowe was prospering around the Bath Hotel. The Empress of Germany, along with her children and retinue of servants, rented South Beach Mansions and South Cottage during their visit in 1891. The royal yacht *Hohenzollern* is anchored in the bay. In 1892 Felixstowe was described as a 'pleasant and rapidly spreading village', and by 1911 the population had risen to nearly 10,000.

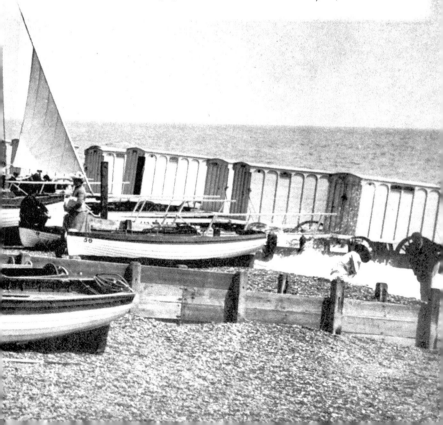

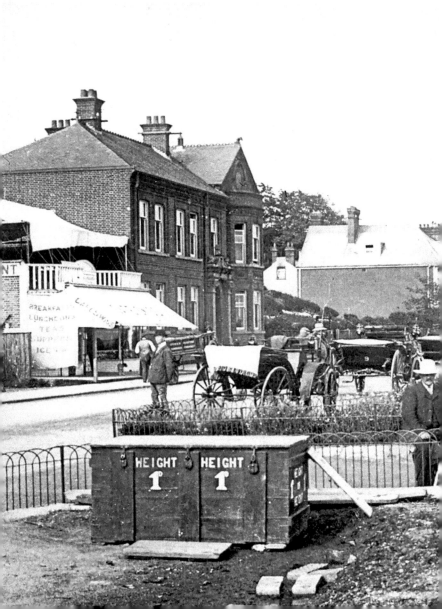

25. SEAFRONT, C. 1912

Jockey scales were a feature of many seafronts so that people could see how the sea air and food were doing them so much good. In this image, horse-drawn carriages line the road in front of the café and the Town Hall. The Town Hall was built by the Local Board of Health in 1892 on a site given by Mr E. G. Pretyman, the Lord of the Manor, who was the heir of Colonel Tomline. The foundation stone was laid by Mr Felix Cobbold. The town council refurbished the building in 2008.

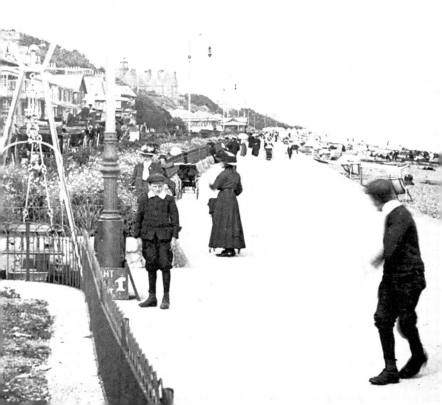

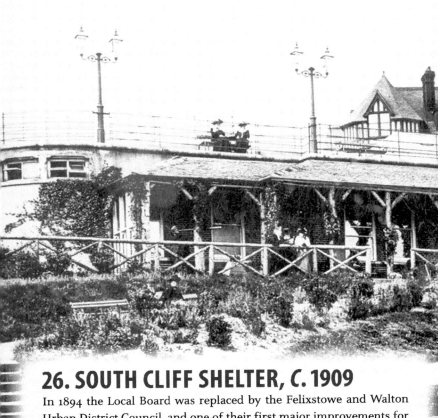

26. SOUTH CLIFF SHELTER, C. 1909

In 1894 the Local Board was replaced by the Felixstowe and Walton Urban District Council, and one of their first major improvements for residents and visitors was the building of the South Shelter in Wolsey Gardens, next to the Town Hall. There were cloakrooms, toilets and a central hall with refreshments. In 1983 the shelter was removed after having fallen into disrepair, but it has now been replaced as part of the £2.7 million renovation of the seafront gardens.

39298

South Clif

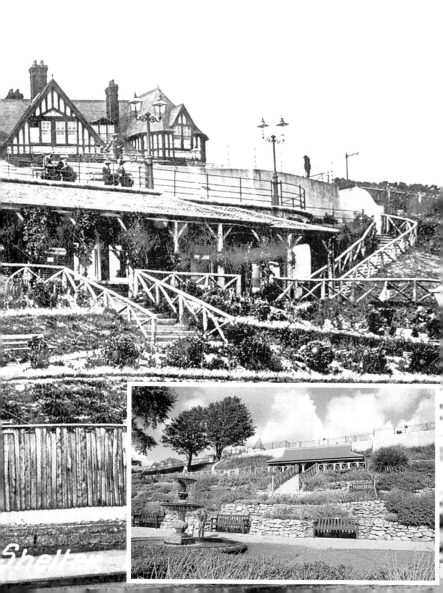

Shelter

27. PARADE AND MEMORIAL, C. 1923

The war memorial was unveiled in August 1920 and recorded 163 names from the First World War. Despite the dove of peace symbol at the top of the Corinthian column, the Second World War saw another 111 names added to the memorial.

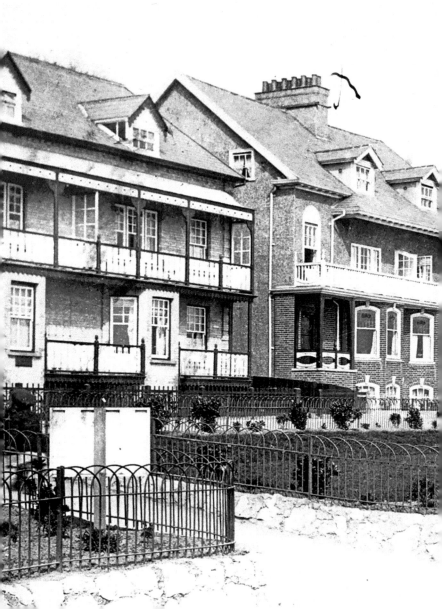

28. UNDERCLIFF ROAD, C. 1908

Over 100 years on and this section of the seafront is instantly recognisable from the image here of it in around 1908, although there have been many subtle changes to some of the properties. The first property was the Empire Café for many years. In 1926 Leslie Cordy bought two houses on Undercliff Road West, demolished them and built the Alexandra Restaurant on the site, opening it for the 1927 season. In 2000 the Yeo Group bought the business, and a second refurbishment in 2010 created the popular Alex Café Bar with a brasserie on the first floor.

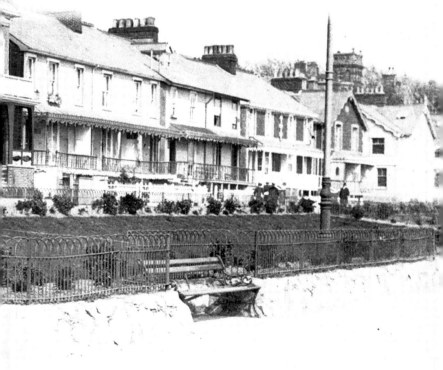

29. WOLSEY TERRACE, C. 1908

The late nineteenth-century development of the town saw the building of many fine properties on the cliffs with stunning views of the bay. The building in the distance at the top of Convalescent Hill is the late Victorian Kilgarth House, which was later converted into apartments known as Kilgarth Court.

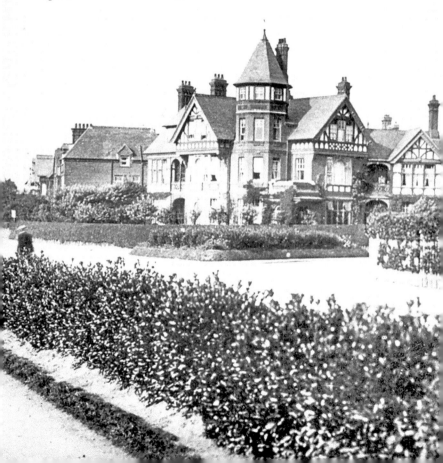

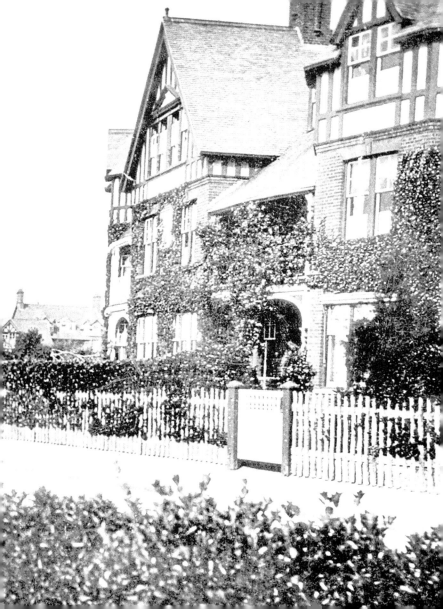

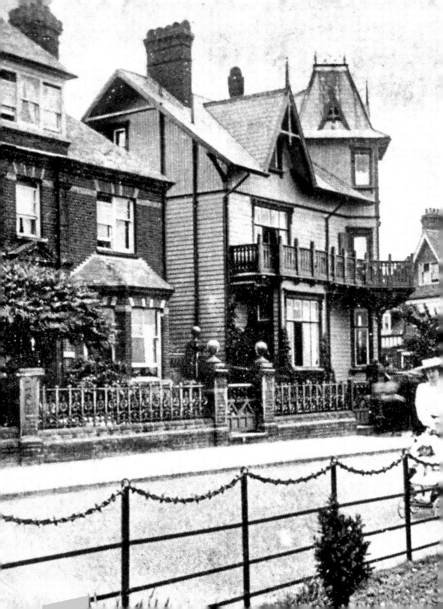

30. THE WOLSEY TERRACE, C. 1909

The wooden-clad building with its distinctive turret was the Eastward Ho! College for Boys, which was established in 1883. After a period as the Glenroy Hotel, it became St Peter's School and the building alongside it became the Eastward Ho! Hotel. Both buildings were demolished in 1971. Wolsey Court now stands on the site. The corner of the Waverley Hotel can be seen. Once one of the resort's oldest hotels, it was converted into apartments in 2014.

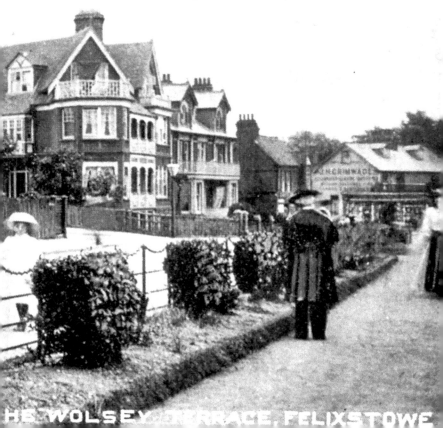

HE WOLSEY TERRACE, FELIXSTOWE

31. GRAND HOTEL, C. 1910

The Grand Hotel dated from 1877 and was extended and renovated by T. W. Cotman in the early 1900s. After the Grand closed in the 1980s, part of it became The Cork public house, named after the *Cork* lightship that could be seen from the seafront. Further along Undercliff, the two houses that were demolished when the Alexandra Café was built in 1927 can be seen.

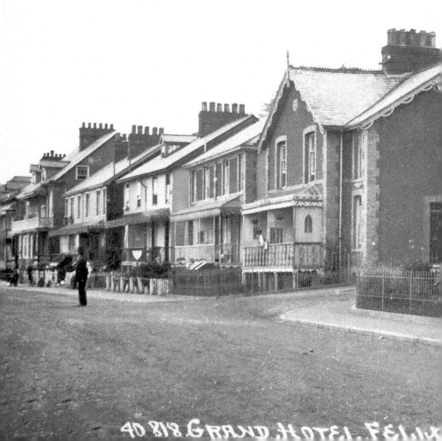

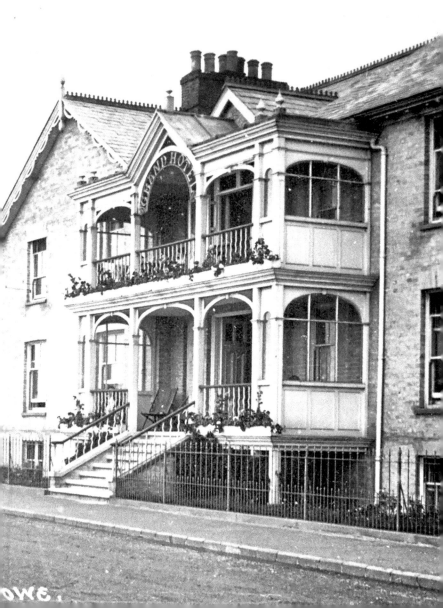

32. UNDERCLIFF, C. 1902

A boy rests with his goat cart opposite Swiss Cottage – one of the wooden houses built by John Chevallier Cobbold at the foot of the cliffs. Pipes collected water from the cliffs to supply the houses. This photograph is taken before the pier, promenade and its gardens were all built. In 1902 the Urban District Council purchased the central cliff and began creating the gardens.

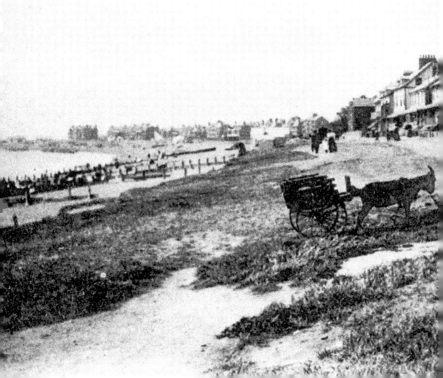

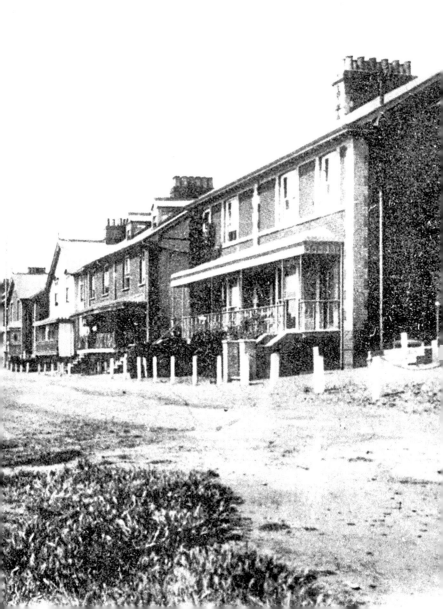

33. THE GARDENS, C. 1934

Known as the Ranelagh Steps Gardens and running below South Beach Mansion (which was built by Eley, the manufacturer of gun cartridges), this was where the Empress of Germany stayed. There was a pram walk through these gardens, which conjures up pictures of uniformed nannies walking their young charges. Wealthy families might have come down for the season and brought their domestic staff with them.

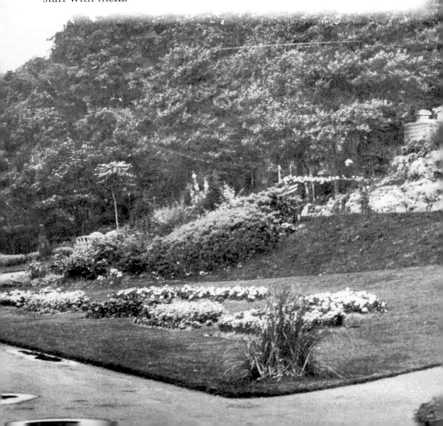

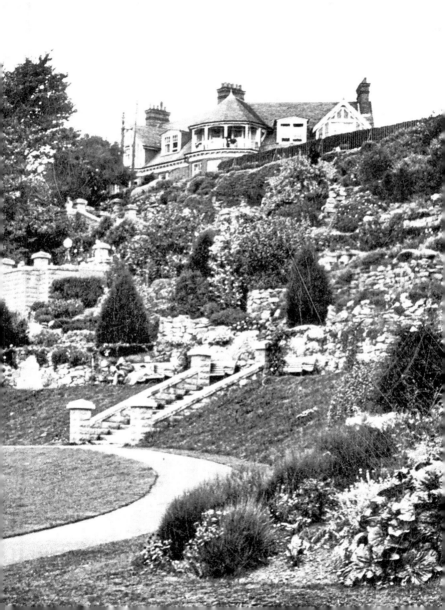

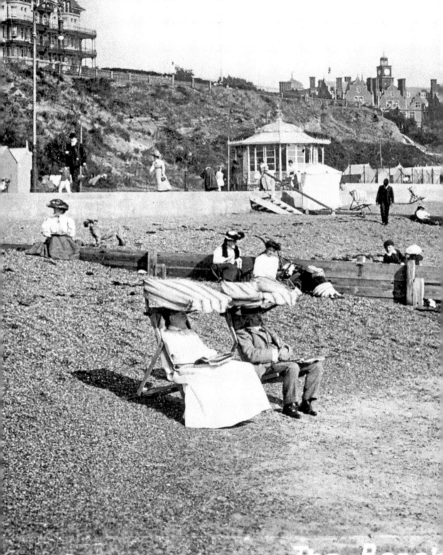

23728 The Beach

34. THE BEACH, 1908

The Cliff Hotel, which was built in 1908, can be seen here along with a splendid new bandstand at the foot of the cliffs. In 1909 this bandstand was incorporated into the new Spa Pavilion. As well as the seawater cure, Felixstowe had the added attraction of a natural spring situated below the cliff, which meant it could promote itself as a spa. A pump was installed and the water was described as 'Similar in taste to Apollinaris, and recommended in its aerated state, as a gentle aperients, anti-dyspectic, and anti-gout water.'

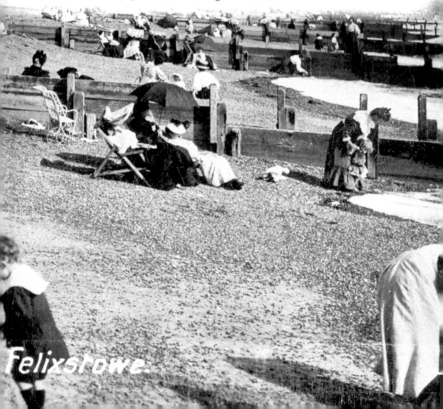

Felixstowe.

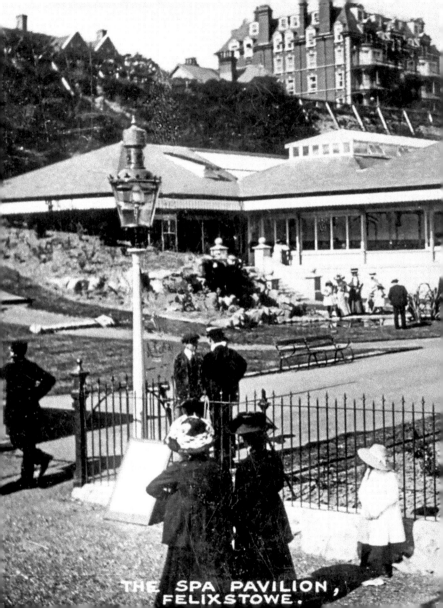

THE SPA PAVILION, FELIXSTOWE.

35. SPA PAVILION, C. 1910

The first Spa Pavilion was designed by Harry Clegg, the council's surveyor. There was seating for more than 600 people and it was based on the Floral Hall at Bridlington and known for a time as the Floral Hall. It became a popular entertainment venue. There were resident orchestras and always a concert party season. In 1938 it was demolished and replaced by the Spa Pavilion, which had been designed as a theatre.

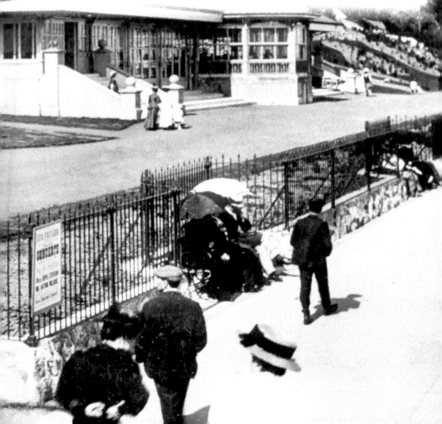

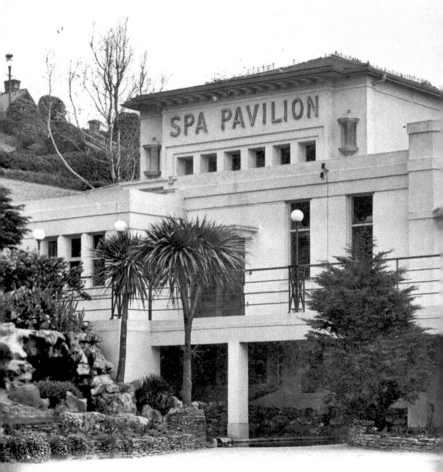

36. SPA PAVILION, C. 1950

Damaged by bombing in 1941, the Spa Pavilion reopened in 1950 and was extended in 1973.

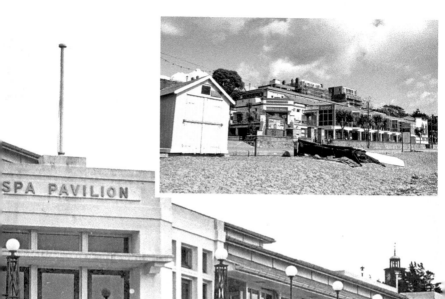

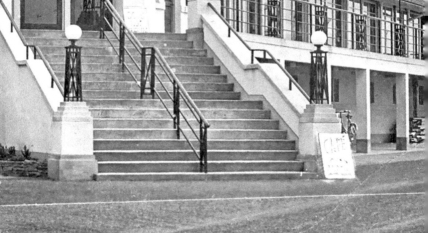

SPA PAVILION

SPA PAVILION. FELIXSTOWE.

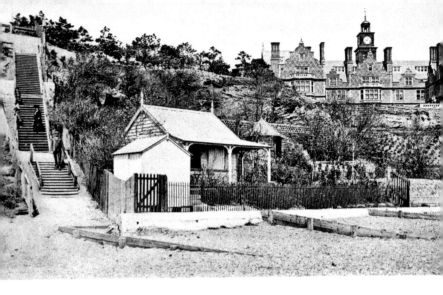

37. STRAIGHT STEPS, C. 1904

The new Felix Hotel and its cliff gardens can be clearly seen here. The tennis courts and croquet lawn ran alongside the Bath Road, the other side of Cobbold Road and at the rear of the Bartlet, where the Felixstowe Lawn Tennis Club courts have been since 1884. The cliffs in the foreground have yet to be landscaped.

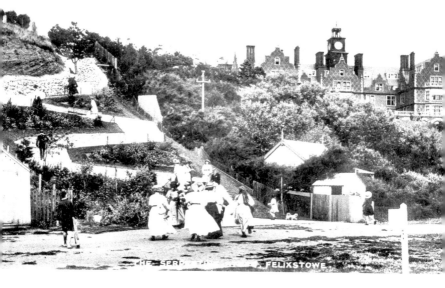

38. THE SERPENTINE STEPS, C. 1912

The Serpentine Steps were completed in 1907, replacing the Straight Steps. They appear to be constructed from Pulhamite, which was a speciality of the local firm Pulham Builders. They made the artificial stone from sand, shale and cement.

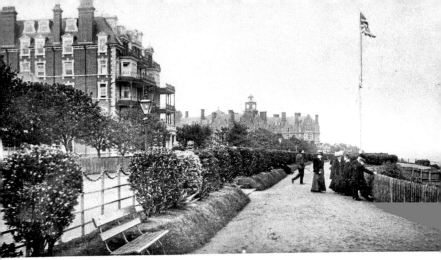

CLIFF GARDENS, FELIXSTOWE.

39. HAMILTON TERRACE, *C.* 1905

Quilter's Cliff Hotel, with its magnificent balconies, was built in 1908. In 1956 the Cliff Hotel was bought by Fisons, who had already acquired the Felix Hotel. They removed the balconies and refurbished it. After a period as offices, Cliff House is now luxury apartments.

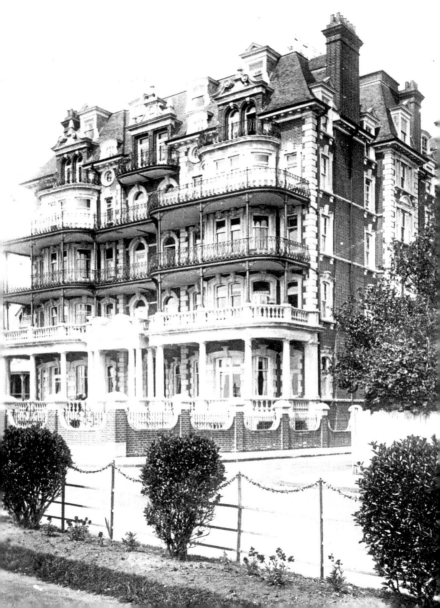

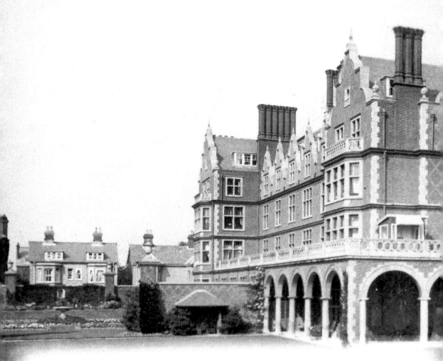

40. FELIX HOTEL, *C.* 1923

Originally called The Balmoral, there was an early change of name for this hotel, which was often described as 'the finest hotel on the East Coast'. Thomas William Cotman designed it for the Ipswich brewer Douglas Tollemache, and it opened in May 1903. Its gardens ran down the cliff to the seafront. In 1919 it was bought by the Great Eastern Railway. In 1936 it was advertised as having '250 rooms with Hot and Cold Running Water. Radiators in most rooms. Ball Room. Hot and Cold Sea Water Baths, 8 Hard tennis courts, 20 grass tennis courts, 2 full sized croquet lawns, 18 hole putting course'.

"D.P" -621.68 FELIX HOTEL FELIX STOWE

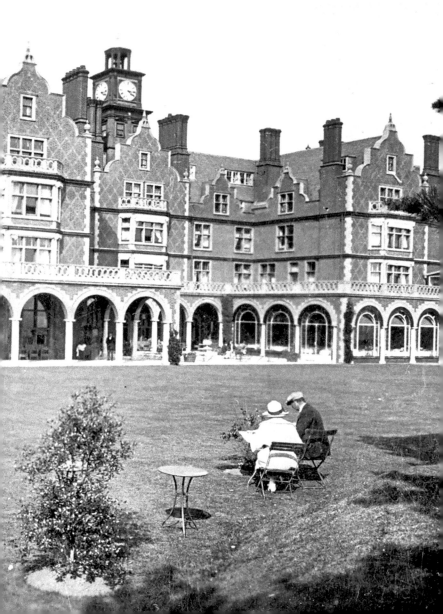

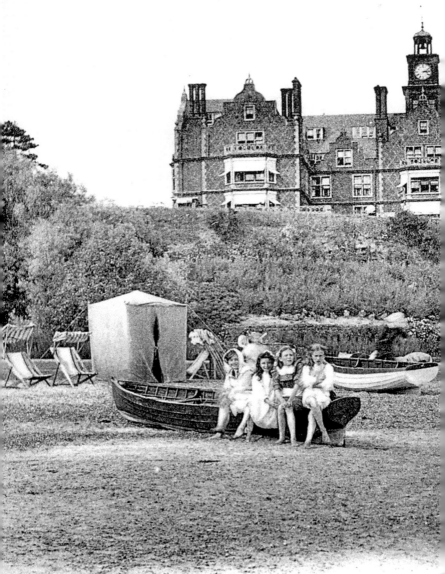

13 FELIXSTOWE. — *Felix Hotel from Beach.*

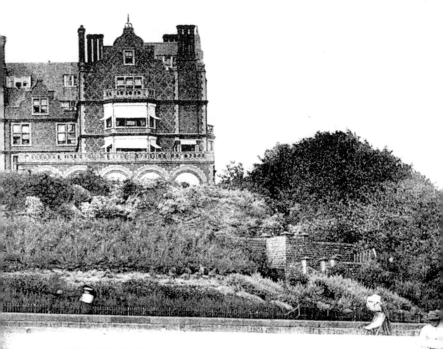

41. FELIX HOTEL FROM THE BEACH, C. 1913

In 1952 the building was bought by the Fisons group, converted for office use and renamed Harvest House. Norsk Hydro took over the offices in 1982, but in 1985 the building was converted into luxury flats for the over fifty-fives, thus keeping one of the resort's most iconic buildings.

- LL.

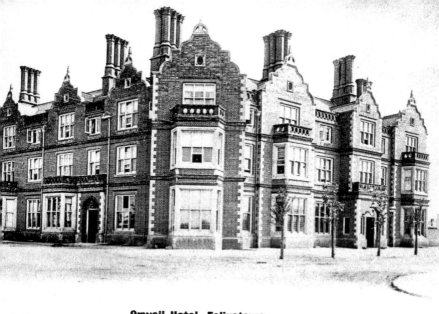

Orwell Hotel, Felixstowe

42. ORWELL HOTEL, C. 1908

Douglas Tollemache, who built the Felix Hotel, had already opened the Orwell in 1898 opposite the new Felixstowe Town station, so it was perfectly placed for the growing numbers of rail visitors. In the 1930s the Orwell was advertised as 'The Garden Hotel ... Close to Sea Front ... Nearest Hotel to Golf Links.' Its private grounds and gardens included an eighteen-hole putting course. It was refurbished in 2003 with fifty-eight en-suite rooms and retains all of its traditional charm. For some time in recent years it was known as the Elizabeth, but now it is the Orwell once again.

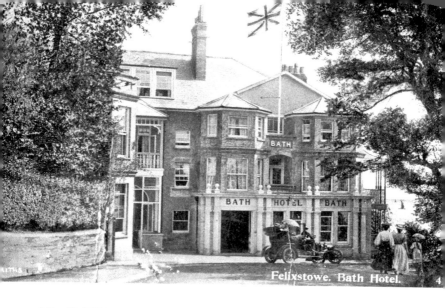

Felixstowe. Bath Hotel.

43. BATH HOTEL, C. 1908

The Hamilton Hotel was built by John Chevallier Cobbold in 1839. Over the years the hotel was greatly extended and the name was changed to the Bath, presumably because of the popularity of seawater baths and bathing. On 28 April 1914, before the hotel opened for the summer season, it was destroyed in a fire caused by Hilda Burkett and Florence Tunks – militant suffragettes. It was never rebuilt as a hotel but the surviving part – once a nurses' home – is now incorporated in Cautley House as a companion development to The Bartlet.

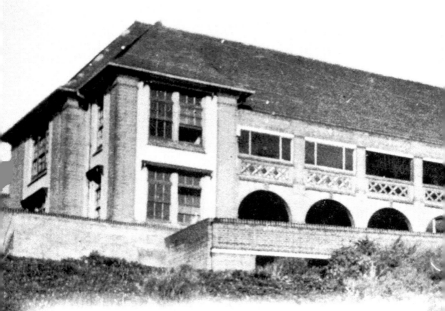

44. BARTLET CONVALESCENT HOME, C. 1936

Dr John Henry Bartlet, former governor and surgeon at the East Suffolk and Ipswich Hospital, bequeathed money for a new convalescent home in his will. It was opened in 1926 and the building incorporated Martello Tower R into its foundations. The Bartlet closed at the end of January 2008 and has been converted into luxury apartments.

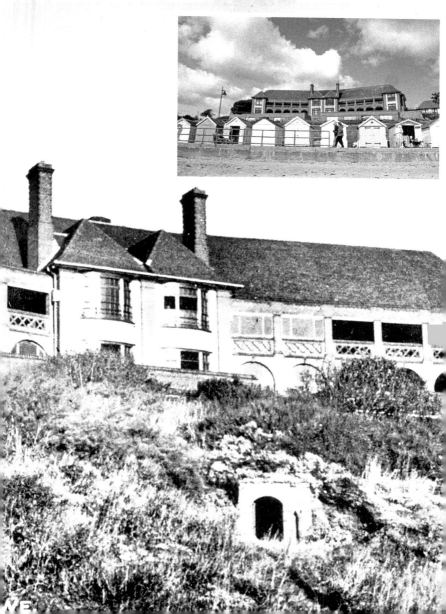

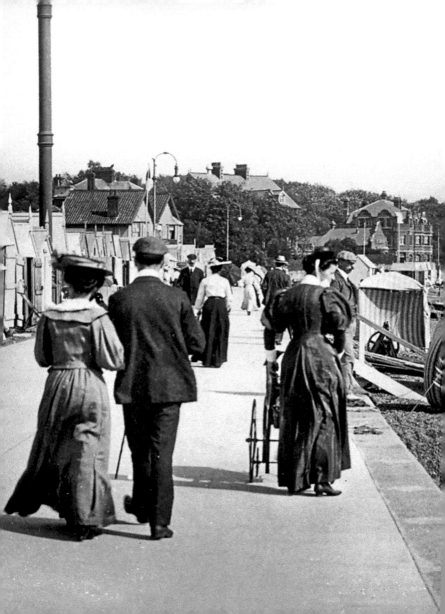

45. COBBOLD'S POINT, C. 1912

The Fludyer Arms Hotel (visible in the middle distance) began as a wooden building around the same time as the Bath Hotel. William Smith, the licensee, operated bathing machines and hot and cold saltwater baths. The present building was renovated by the Yeo Group as a fourteen-room pub/restaurant, which dates from 1903. Samuel Fludyer owned Felixstowe Lodge and then sold it to John Chevallier Cobbold.

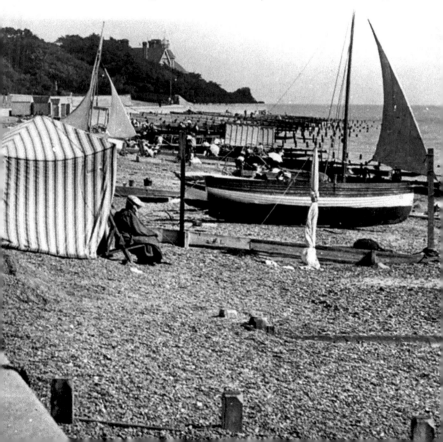

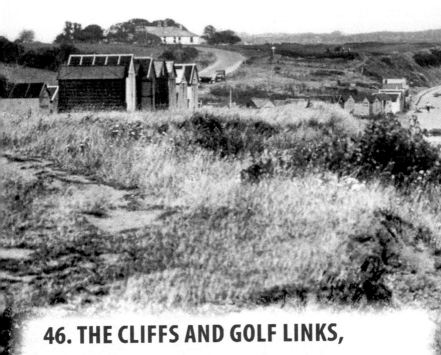

46. THE CLIFFS AND GOLF LINKS,
C. 1928

There is a delightful sweep of the cliffs and lovely sands as the coast curves round towards the mouth of the River Deben and Felixstowe Ferry. The golf club was founded in 1880; it is one of the earliest in England and was later considered to be one of the finest in Europe. The Right Honourable Arthur Balfour (prime minister from 1902–05 and foreign secretary from 1916–19) was captain of the club in 1887.

GOLF LINKS AND CLIFFS, FELIXSTOWE.

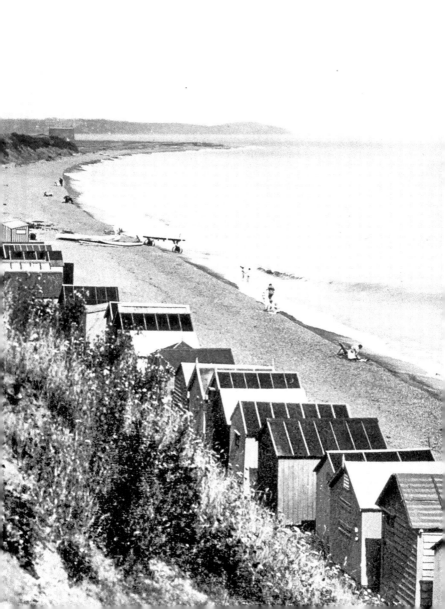

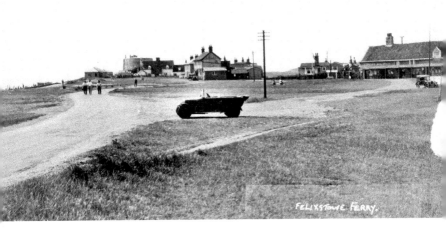

FELIXSTOWE FERRY.

47. FELIXSTOWE FERRY, 1920S

A wide view before the clay sea wall was built in 1970. The building to the left of the Martello tower – the ladies' clubhouse for the golf course – was lost to the sea. The Old Manor House can be clearly seen on the right, along with the then Victoria Inn and the Ferry Boat Inn. The Ferry soon became a favourite destination for weekend motorists.